British Museum Object

T0276516

The Franks Casket
Leslie Webster

THE BRITISH MUSEUM PRESS

First published in 2012 by
The British Museum Press
A division of
The British Museum Company Ltd
38 Russell Square
London WC1B 3QQ

britishmuseum.org/publishing

A catalogue record for this book is
available from the British Library

ISBN 978-0-7141-2818-4

Designed by Esterson Associates
and Bobby Birchall, Bobby & Co.
Typeset in Miller and Akzidenz-
Grotesk
Printed and bound in China by
Toppan Leefung Printing Ltd

The papers used in this book are
natural, renewable and recyclable
products and the manufacturing
processes are expected to conform
to the environmental regulations
of the country of origin.

The majority of objects illustrated
in this book are from the collection
of the British Museum. The British
Museum registration numbers for
these objects are listed on page 64.
You can find out more about objects
in all areas of the British Museum
at britishmuseum.org.

Author's acknowledgements
I am indebted to many fine scholars
who have written on the Franks
Casket, too many to mention; but I
would like to single out Ian Wood, the
late Jim Lang and Carol Neumann de
Vegvar as friends and colleagues who
have inspired, both in discussion and
through their published work. The
translations of the inscriptions rely
heavily – though not exclusively –
on those of the late Ray Page, who
was also a source of invigorating
scepticism over many years. For advice
and support on a modified reading of
the front panel text, and at a time
when he had more important things
to distract him, my thanks to David
Parsons. For generous sharing of
information on the thirteenth-century
records at Brioude, I am indebted to
Professor Gabriel Fournier. I am very
grateful to my former colleagues
Marjorie Caygill, Stephen Crummy
and Sonja Marzinzik for their help in
key matters, and to my two editors at
BMP, Felicity Maunder and Emma
Poulter, who have been unfailingly
positive throughout this book's long
journey to publication, which has also
benefited from Belinda Wilkinson's
input. Finally, special thanks are due
to David Wilson and James Graham-
Campbell for commenting on this
book in early draft.

Contents

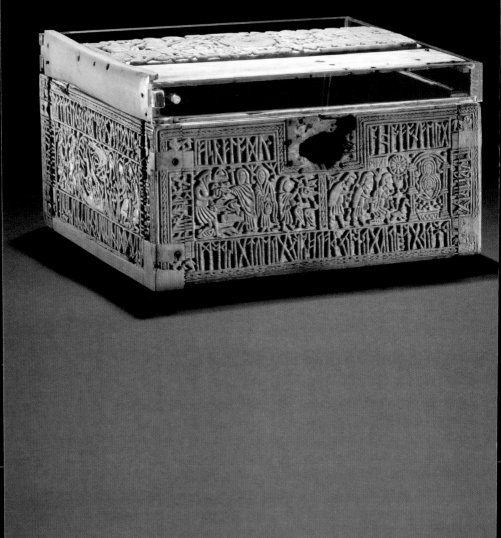

Prologue

1 The Franks Casket.
Anglo-Saxon, AD 700–
750, Northumbria,
England. Whale-bone,
L. 23 cm; W. 19 cm;
H. 13 cm. British
Museum.

Not long before his death in 1986, the great Argentinian writer Jorge Luis Borges, who was blind, made a special visit to the British Museum in order to fulfil a long-held wish to touch the Franks Casket and trace the stories it tells (fig. 1). It was a lifelong fascination with Anglo-Saxon language and literature that had first kindled Borges's interest in the eighth-century Anglo-Saxon whale-bone box; the relief carvings of animated figures and elaborate inscriptions which cover every inch of this supremely tactile object, made that distant world come alive for him in a unique way.

Borges's engagement with the casket is memorable because of his reputation as an author who famously wrote about enigmas, but it also reflects the extraordinary impact that this box has had since its discovery in the nineteenth century. Its vivid and enigmatic carved decoration has intrigued and puzzled, while the fact that it preserves the earliest recognizable versions of famous legends from Germanic tradition, the longest complete runic texts, and the earliest examples of narrative art from Anglo-Saxon England makes it a unique window on to the early medieval world – and at a particularly significant moment of transition, as the Anglo-Saxons renounced their older pagan religion, and adopted Christianity.

The Franks Casket is named after the scholar and collector Augustus Wollaston Franks, who gave it to the British Museum in 1867, shortly after he became Keeper of the Department of British and Medieval Antiquities there. The department had been created the year before, in part to develop the Museum's collection of national antiquities, to match the grand holdings from the ancient world of Assyria, Egypt, Greece and Rome. The casket, with its runic inscriptions and scenes from Germanic legend, was thus a great and timely prize for the Museum, an icon of Anglo-Saxon culture in a period when the origins and

identity of English institutions such as the Anglican Church, the legal system, and the monarchy itself, were being ascribed to a sturdy, independent Anglo-Saxon tradition. Yet ironically, this iconic Anglo-Saxon object was first discovered in obscurity in France, in Auzon, a village in the Auvergne; for this reason, it is also known as the Auzon Casket.

Today the casket preserves the pale, glossy surface of the whale-bone from which it is carved, without colour or embellishment, but its original appearance was much richer (fig. 2). Stained with bright colours, clasped and fitted with silver or gilt-bronze mounts, some possibly jewelled, it was clearly a treasured object, made for some grand purpose.

What the true meaning, function and history of this extraordinary piece were, how it came to be discovered in nineteenth-century France, and why it has continued to be an object of veneration and fascination for most of its long existence will be explored in this book.

2 A reconstruction of the casket as it might once have appeared, with metal fittings, jewelled insets and brightly coloured panels. Computer generated image by Stephen Crummy, British Museum.

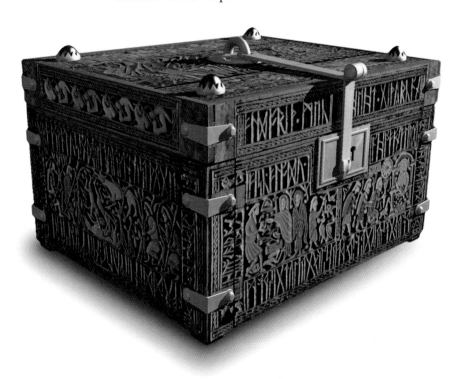

Introduction
A riddle wrapped in a mystery

At first sight, the Franks Casket is a strange and perplexing piece, which seems to guard its secrets. The scenes that decorate its sides and lid are crammed with detail and have also been chosen from a curious mixture of sources – Germanic and Roman legend, Jewish and Roman history, and the New Testament – few of which are instantly recognizable to us. The inscriptions that frame the scenes are equally puzzling; mostly written in the Anglo-Saxon runic alphabet, the *futhorc*, and in Old English, the language of the Anglo-Saxons, they perform ostentatious contortions, some running backwards, some upside down, others shifting into Latin and Roman lettering; one is even encrypted. The meaning of the scenes and the inscriptions has to be patiently unpicked, and the clues to the overall intention behind this extraordinary object are far from obvious.

In fact, its Anglo-Saxon owner would also have found the casket intriguing and challenging; it was ingeniously designed from the outset to tease the eye and exercise the mind. But in the learned context in which it was made, in early eighth-century Northumbria, its riddling nature would have certainly been less surprising than it seems to us. To help put the casket into that contemporary perspective, a bit of background is necessary.

First of all, the casket would certainly have been regarded as a prestige object in its day, not just because of its intricate craftsmanship and complex decoration, but because of the very material from which it is made. A stranded whale was a great resource, highly prized for its meat and blubber, and for the bone that came from its jaws, which provided large, fine-grained plates suitable for carving, a worthy substitute for the even scarcer elephant ivory. In medieval times, it became a royal privilege, and it is likely that already in the Anglo-Saxon period (*c.*400–1100), such prized resources would have been claimed by the king or the Church. Transformed into a handsome box, richly carved and

3 Runes are the letters from the related runic alphabets which were used by various Germanic tribes, including the Anglo-Saxons, from the mid second century. Their angular shapes were well-adapted for carving in wood, bone and stone (detail, front panel, right).

possibly painted, embellished with glittering metal fittings, the precious whale-bone was used to create a very special container for a very special object. But as we shall see later on, the whale-bone also carried a particular symbolic significance in the overarching message that the casket embodies – the first of many riddles contained in this enigmatic box.

The casket was made a hundred years or so after the first Christian missions from Rome reached the Anglo-Saxons in 597. Before that, the pagan Anglo-Saxon incomers had worshipped an array of Germanic gods which had accompanied them across the North Sea from their homelands in northern Germany, Frisia and southern Scandinavia. The rich tradition of legend which surrounded this religion was deeply embedded in Anglo-Saxon culture, and many traces of these tales survive in Anglo-Saxon and medieval literature, as well as in place-names, and in the names of the days of the week that we still use today. Long after the adoption of Christianity by the Anglo-Saxons, these old Germanic legends continued to thrive, and as we shall later see, some of them were used by the maker of the casket for a very particular purpose.

On the casket, the scenes illustrating Germanic stories would have been understood without the need for accompanying words; one has no explanatory text, and the other two have brief labels and, in one case, an encoded and obscure verse inscription, suggesting that these scenes were fully familiar to their audience. By contrast, the three scenes drawn from classical or Judaeo-Christian tradition all have explanatory texts, even the Adoration of the Magi, who are identified by a label. These three scenes illustrate subjects that would have become known in England through the Christian Church, and with their inscriptions show that the casket was clearly made for a literate and educated owner.

Literacy, in the sense of being able to read manuscripts written in the Roman alphabet we use today, had been introduced by Roman and Irish Christian missionaries into Anglo-Saxon England at the beginning of the seventh

century, as a vital aid to the Church's worship and teaching. Copies of sacred texts and service books were essential to the work of the Church, and soon writing began to be used in many other contexts – on monumental stone crosses and other sculpture, to issue charters and laws, and in historical records and works of learning. Before this, writing among the Anglo-Saxons was confined to short inscriptions carved in runes – the ancient letters used by Germanic tribes (fig. 3) – incised, or occasionally stamped on metal, wood, bone and pottery. The surviving inscriptions that have come down to us from that early period are mostly magical charms intended to bring good fortune, or record the name of the owner or maker (e.g. fig. 31). But these inscriptions were also important images in their own right, meant to be seen as well as read. Highly literate as they are, the elaborate inscriptions on the Franks Casket were also conceived as images as well as texts, as the many tricks in their layout and their decorative appearance show. They sit in a long Anglo-Saxon tradition of playing with images to be read, a tradition which reaches back to the early runic inscriptions and to the highly stylized animal ornament that decorated the jewellery and other prestige objects of the early pagan Anglo-Saxons. This tradition continued long after literacy had become established in monastic and royal circles.

A strong current of riddling play also underpins the way in which these early complicated images and texts were used. As we shall see, the maker of the Franks Casket took this tradition to new heights. Substantial surviving Anglo-Saxon collections of riddles in Old English and Latin show that they were both a favoured teaching aid for the Church, and part of a long – and very lively – oral tradition. The casket embodies both these strands in its subtle interplay of religious and vernacular themes, constructing a three-dimensional riddle which challenges the viewer to discover its artfully concealed meaning. There are many riddles to be puzzled over in the quest to understand what that was, and for whom it was made.

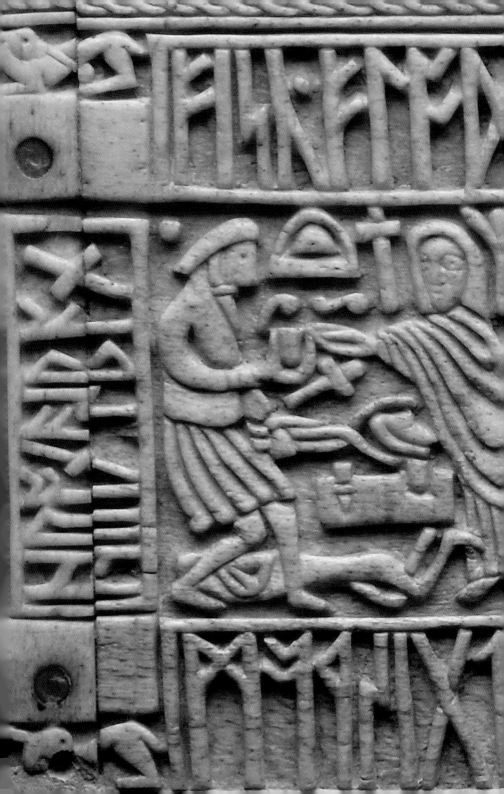

Chapter 1
A tale of a whale and other stories

Manufacture and appearance

The Franks Casket is a rectangular, lidded box, 23 cm in length, 19 cm deep, and 13 cm in height. Scientific examination has confirmed that the box is made of whale-bone from northern waters, as the answer to the riddle on the front panel implies – 'whale's bone' (fig. 4). Although no trace of colouring has survived the handling, cleaning, and cast-taking of the last 1,300 years, the casket was probably originally brightly coloured (fig. 2), like contemporary Anglo-Saxon manuscripts and some stone sculpture.

The four wall panels which compose the base are fixed by tenons and dowels into corner uprights, neatly shaped on their internal faces. Originally two floor plates (one now missing) slotted into grooves at the base of the wall panels. All show signs of ancient damage, and the left side and lid have been repaired using iron plates, which have left rusty vestiges (figs 6–7).

The lid probably originally consisted of three separate plates of equal size, slotted into edging strips. Of the two plates that survive, the central lid panel is decorated with an apparently complete scene, while the much thinner undecorated plate might be a later replacement, or designed to be covered with metal sheeting (fig. 5). Only one plain edging strip, an evident replacement, survives on the left end panel. The lid sits lightly on a low ledge which runs around the upper edges of the base. Its decorated panel has a plain central disc with rivet holes for a substantial metal fitting, probably a decorative plate, incorporating a handle or, more plausibly, a hinged metal fastening, or 'hasp', connected to the lock-plate below (fig. 2). The lock itself has been roughly hacked out from the front panel at some time in the past; it was probably spring-operated, a type known from Anglo-Saxon England (fig. 8). Traces of other lost metal fittings are visible elsewhere: metallic staining shows that, on each corner post, two lozenge-shaped hasps were originally

BACK PANEL

Scene with hostages

Ark of the Covenant (centre)

Flight of the Jews

Hinge marks

Roman legend of Romulus and Remus

LEFT END PANEL

LID PANEL

The archer Egil defends a fortress against a fierce atta

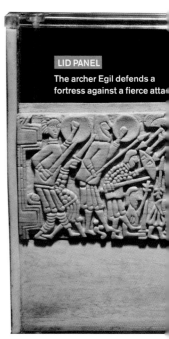

Edging strip

FRONT PANEL

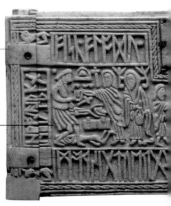

Germanic legend of Weland the Smith

5 Layout of the Franks Casket, showing clockwise from the top: back panel, right end, front panel, left end, with the lid in the centre.

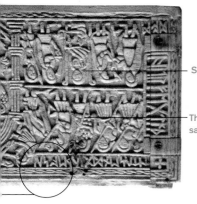

Scene of judgement

The Romans led by Titus sack Jerusalem

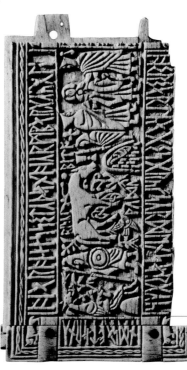

Unidentified Germanic legend

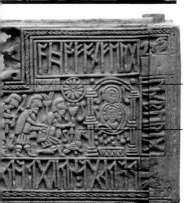

Lock position

Adoration of the Magi

RECONSTRUCTION

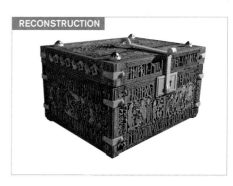

6 *Right* The underside of the lid, showing ancient repairs.

7 *Below* Interior view, showing the shaped inner face of a corner post, and traces of an ancient repair.

riveted into the dowels attaching the panels, and that hinges once fastened the lid to the base. The hinges appear to have been added as an afterthought, since they obscure parts of the text on the back panel (fig. 11). It is also possible that decorated or inscribed metal sheets were once attached to the plates flanking the central panel on the lid, the only panel to lack an extended accompanying text. The right end panel (fig. 14), which became separated from the others in the nineteenth century and is now in the Bargello Museum, Florence, is replaced by a cast on the reassembled casket in the British Museum.

A set of linked stories
The scenes that decorate the sides and lid of the Franks Casket are selected from a variety of sources – Germanic and Roman legend, Jewish and Roman history, and the Christian New Testament – and are juxtaposed in a subtle narrative scheme. The texts that accompany the scenes are mostly written in the Anglo-Saxon version of the runic alphabet, the *futhorc*, and in Old English, the language of the Anglo-Saxons. The texts provide a commentary – not always an obvious one – on the episodes depicted. As we shall see, it seems probable that the scenes were in fact meant to be read in pairs, something hinted at by the twinned scenes facing each other on the front panel (figs 5 and 8).

The front panel is the only one containing two distinct scenes. It is also the only one whose main inscription does not overtly describe the images it surrounds. The scene on the right shows the Adoration of the Infant Jesus by the three wise men or Magi, who were also described as kings by early Christian writers. Preceded by a small bird, perhaps representing the Holy Spirit, the Magi approach the enthroned Virgin Mary who, following a contemporary Roman convention, is portrayed displaying the image of Jesus in an oval frame (*clipeus*). The Magi offer their traditional gifts of gold, frankincense and myrrh (a resin used in embalming). A small runic text (top right) identifies the kings as '*mægi*', and the guiding star shines overhead. Opposite the Adoration, on the left, is a strange scene that could hardly be more different; it needs explanation

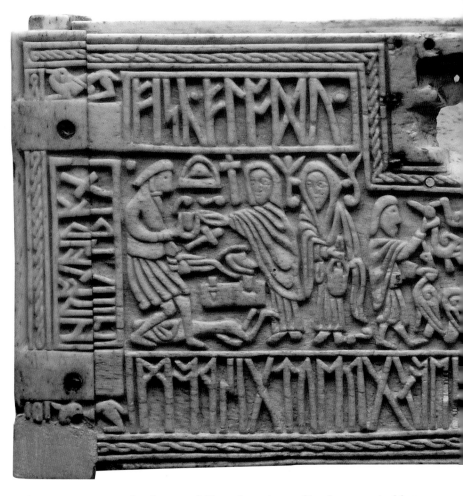

8 The front panel of the casket with two contrasting scenes from Christian and Germanic legend. On the left (above), Weland the Smith takes revenge on the children of his captor. On the right (opposite), the Three Kings (Magi) pay homage to the Infant Jesus.

today, but would have been immediately recognizable to an Anglo-Saxon audience. It represents a scene from the legend of Weland the Smith, known throughout Germanic Europe. The famous smith was exiled, imprisoned and cruelly lamed by the legendary King Nithhad, who forced him to work for him. Weland took a terrible revenge, murdering the king's two sons and turning their skulls into jewelled cups. He then raped the king's daughter, Beadohild, before making his escape on wings that he had fabricated. The gruesome scene shows Weland at his forge, holding the head of one of the princes in his smith's tongs, while he straddles the decapitated body of the other prince. With his other hand he offers a drugged potion to Beadohild. Behind her stands

16

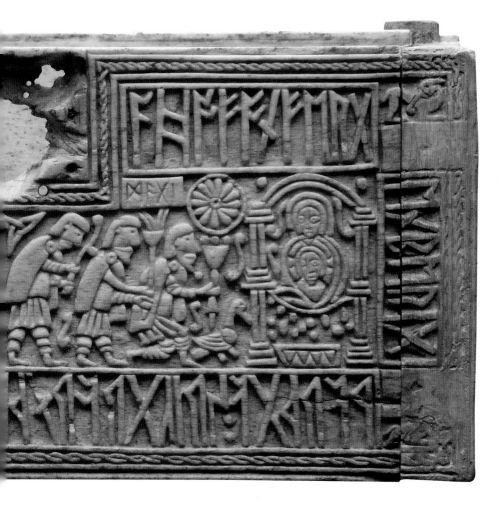

another female figure, perhaps depicting the princess on her way to the smithy, or maybe her attendant. At her right, a small male figure, possibly Weland himself, or his brother Egil, captures birds to make the feathery wings on which the smith will finally make his airborne escape. The front also shares a distinctive decorative detail with the two end panels: a small animal crouches in each corner. The inscription surrounding these scenes, which is in the form of a riddle in alliterative verse followed by its solution, refers to the physical origin of the whale-bone casket: a whale washed up on the seashore. Uniquely on the casket, the inscription on the lower edge runs backwards (underlined below):

fisc flodu ahof on fergenberig
<u>*warþ ga:sric grorn þær he on greot giswom*</u>
hronæsban.

This can be translated in more than one way, but the general sense is clear:

The sea cast up the fish onto the mountainous high beach [or, 'into a rocky burial mound']; <u>the king of terror became sad when he swam onto the shingle</u>. Whale's bone.

9 The lid of the casket depicts the siege of a fortified place. On the left (below), armed warriors attack. On the right (opposite), the archer Egil defends his sanctuary.

The meaning of the scenes and the ways in which they may be connected are explored in depth in Chapter 2.

The scene on the lid (fig. 9) is the only one that lacks any surviving framing inscription. It takes place around the central setting for a lost metal fitting. It is possible that this, and metal coverings on the other two panels, carried

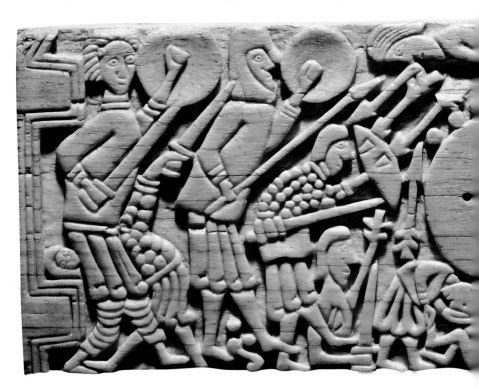

10 *Above* At her head and feet, linked animal heads guard a female figure within the besieged precinct (detail, lid).

supporting images or texts. At each side of the panel is an apparently architectural structure framing the scene, in which heavily armed warriors on the left attack a fortified precinct of some kind, vigorously defended by a lone archer on the right. Behind him, beneath an arch representing perhaps a house or a sanctuary, a female figure proffers another arrow. Above her head and beneath her feet are linked bird- and beast-heads, a long-standing protective motif in Germanic art (fig. 10). Prominent among the attackers on the left is a warrior with a Roman-style crested helmet. The archer's arrows rain down on the attackers, and small naked figures may represent the dead.

The panel has one brief text only (top right), the personal name '*Ægili*', which identifies the archer. Although it has been suggested that the scene represents an episode from the legendary Trojan War, with Ægili taken to refer to the Greek hero Achilles, it is now usually accepted that it depicts a lost episode from the Germanic legend of Egil the Archer – the celebrated brother of Weland the Smith.

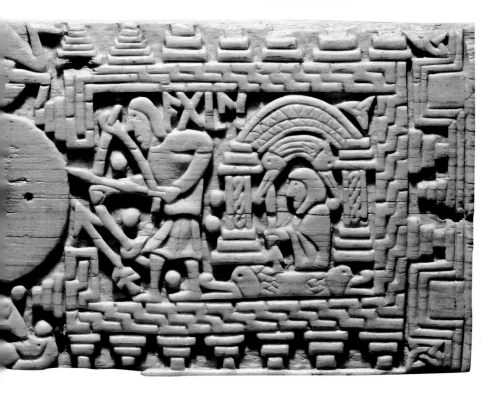

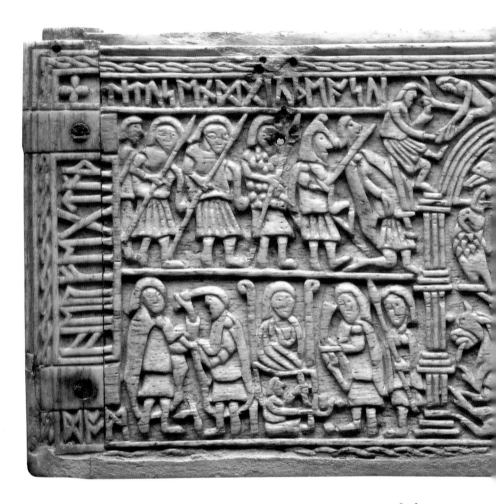

11.1 Divided into four scenes, around an image of the Temple, the back panel depicts the Roman sack of Jerusalem in AD 70. In the upper left, the Roman general Titus leads the assault on the city. In the lower left, a throned figure, probably Titus, sits in judgement.

The back panel is divided into an upper and a lower part, each composed of two scenes on either side of a central arched structure. These all relate to the sack of Jerusalem by the Roman general (and later emperor) Titus in AD 70 (fig. 11). They depict the destruction of the Jewish Temple, and the flight of Jews from the city, together with episodes of trial and hostage-taking. In the upper left scene, Titus, identified by his Roman-style helmet, leads his troops in the attack on the Temple (fig. 11.1), which appears as the arched structure dominating the centre of the back panel. At its heart lies the Temple's inner sanctum, the Holy of Holies,

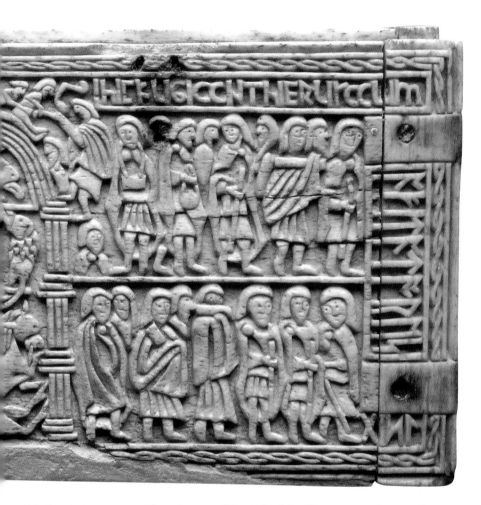

11.2 *Above* In the upper right scene, Jewish fugitives flee Jerusalem. In the lower right, hostages are led away.

with an image of the Ark of the Covenant on its carrying poles. This is surrounded by symbolic creatures: four interlacing eagles above, and below, two beasts, perhaps winged oxen, perhaps maned lions (fig. 12). They may represent the sacred creatures of the Temple, variously described in the Bible as including all these elements. Opposite the sack of the city, in the upper right scene (fig. 11.2), Jewish fugitives escape. In the lower left scene, an enthroned figure dispenses justice, identified by the single word *dom*, meaning 'court' or 'judgment', in the bottom left-hand corner. In the lower right scene, a muffled figure is

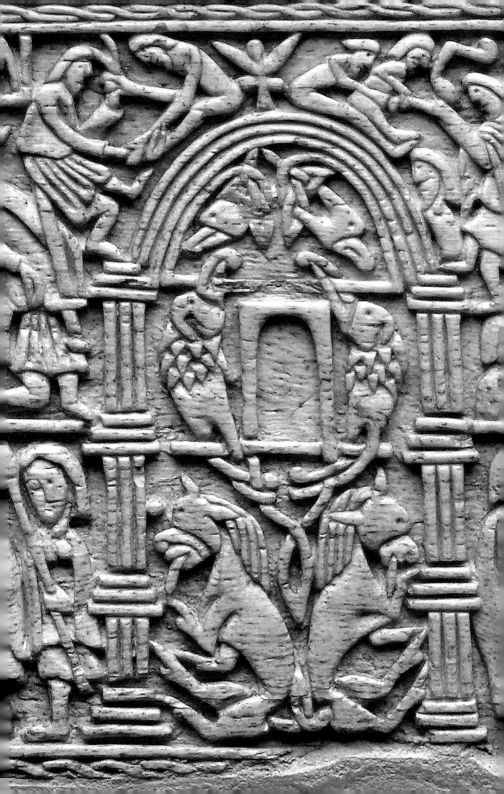

escorted away; an accompanying label in the right-hand corner reads *gisl*, 'hostage'. Some have suggested that the two words are meant to be read together as *Domgisl*, a recorded Frankish personal name. The main inscription refers to the upper register only, and reads:

> *her fegtaþ Titus end Giuþeasu*
> *hic fugiant Hierusalim afitatores.*
> Here Titus and a Jew fight: here its
> inhabitants flee from Jerusalem.

A peculiarity of this text describing the flight of the Jews is that it not only begins in Old English and ends in Latin, but that the Old English words are written in the runic alphabet, and the Latin ones in the Roman alphabet – until they turn the final corner, where the Latin *afitatores* is written in runes. Latin and Roman letters are used nowhere else on the casket. Text that deviates from the normal is unlikely to be accidental here, and usually serves to highlight something – as we shall explore in Chapter 2.

The casket's left end panel illustrates the Roman legend of Romulus, founder of Rome, and his brother Remus, the abandoned twin boys who were rescued and fed by a she-wolf (fig. 13). Here, at the centre of the wood, she is accompanied by her mate, who licks the naked children's feet, while men with spears, clutching at the trees, rush in from either side to rescue them. The inscription reads in Old English:

> *Romwalus ond Reumwalus twægen gibroþær*
> *afœddæ hiæ wylif in Romæcæstri oþlæ unneg.*
> Romulus and Remus, two brothers. <u>A she-wolf</u>
> <u>nurtured them in Rome city</u>, far from their native land.

The underlined words, which run along the lower edge of the panel, are again unique on the casket in being written upside down in relation to the scene.

Like the left end panel, the right end is set in a wild place, with animals at its centre, and it too is divided into three distinct parts (fig. 14). The central scene depicts a horse, with triple knots between its legs, bending over a burial mound

13 The left end of the casket illustrates the Roman legend of the twins Romulus and Remus, who were raised by a she-wolf.

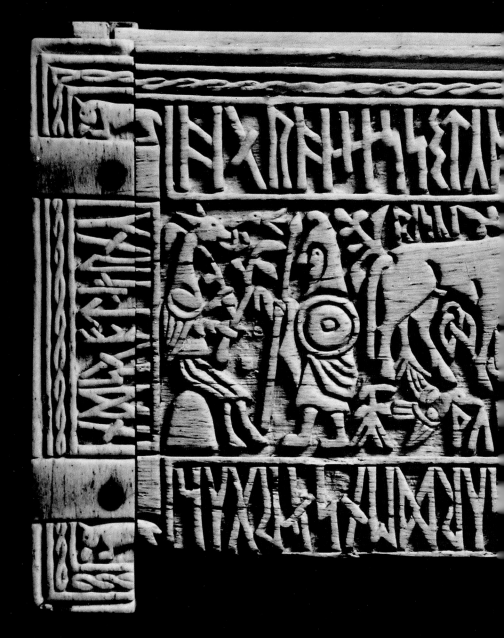

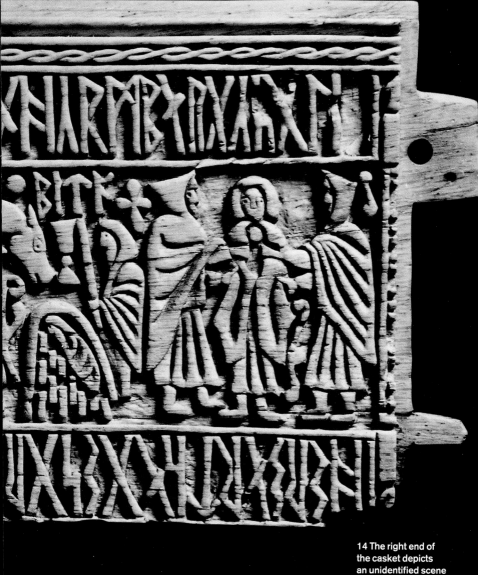

14 The right end of the casket depicts an unidentified scene from Germanic legend. Museo del Bargello, Florence.

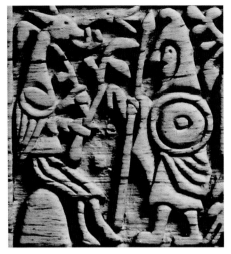 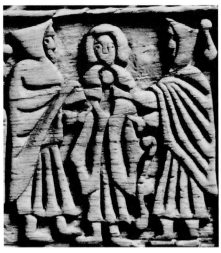

15 *Above left* A strange creature sits on a mound, facing a warrior (detail, right end).

16 *Above right* Two cloaked figures grasp a third (detail, right end).

containing human bones (fig. 17). A female figure with a staff and goblet stands before the horse, and a bird flies below. Three labels, *wudu*, 'wood', *risci*, 'rushes', and *bita*, 'biter' (perhaps describing the horse, or the object carried by the female figure), accompany the relevant elements in the scene. At the left of the horse, a strange winged creature, half-human, half-horse, sits on a mound, its muzzle bound by a serpent. Facing the creature a helmeted warrior, with shield and spear, guards or perhaps confronts it (fig. 15). To the right of the horse, two cloaked figures grasp a third (fig. 16).

The main runic inscription, like that on the front panel, is set in Old English alliterative verse, but it is also ingeniously encrypted using a systematic substitution of older rune forms for all the vowels. These are cleverly derived from the runic letters for the consonants that end the Old English names of the normal runes for the vowels in question – so that, for example, the rune used here for the vowel 'a', which has the rune-name *ac*, 'oak', is represented by a rune form which resembles that for the letter 'c', its final consonant. A possible transliteration of the text is:

Her Hos sitiþ on harmberga
agl[.] drigiþ swa hiræ Ertae gisgraf
sarden sorga and sefa torna.

Here Hos sits on the sorrow-mound;
she suffers distress as Ertae had imposed on her, a
wretched den of sorrows and of torments of the heart.

The personal names Hos and Ertae are Germanic, so the
tale depicted must be of Germanic origin. The inscription
presumably describes the figures on the left, but could also
refer to the group on the right. The central burial mound
with its mourning horse might also be described as a
sorrow-mound. Presumably all three elements belong to
the same story. Some earlier scholars identified this scene
with elements from the legend of the Germanic hero Sigurd,
but the personal names do not support this theory. Despite
the descriptive text, and its distinctive images, the story
depicted on this panel has so far resisted identification.
The intriguing question of why this side alone carries an
encoded inscription will be explored in the next chapter.

17 A horse bends over a burial mound beside a figure with a goblet and staff (detail, right end).

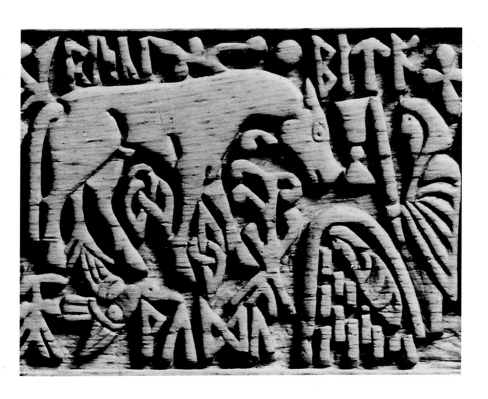

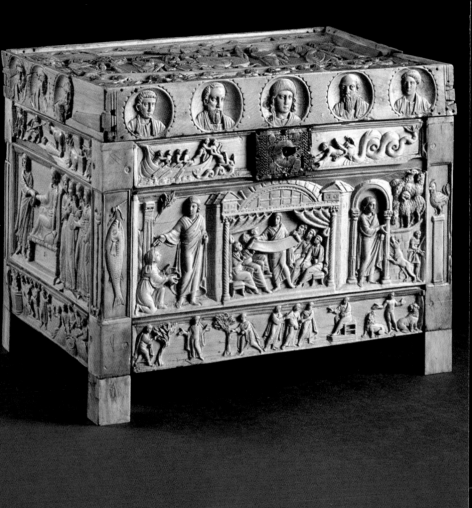

Chapter 2
Deciphering the message

A classical inheritance

On its discovery in the mid nineteenth century, no one quite knew what to make of the Franks Casket. To some earlier commentators, it seemed crude, the product of a barbarian workshop ignorant of the naturalistic art of the Greco-Roman classical tradition considered to be the ideal. Even the twentieth-century art historian Thomas Kendrick, a former Director of the British Museum and usually an astute writer on Anglo-Saxon matters, described the casket as 'arid and incompetent', 'a joyous and inconsequential parade of scenes that were probably intended to have more ornamental than didactic value'. Yet nothing could be further from the truth. The casket is a remarkably ambitious object, whose maker created a unique and eloquent idiom for conveying stories from diverse cultures in a new and accessible way.

Without parallels in Anglo-Saxon England, or indeed anywhere else in the Germanic world, the casket is clearly modelled on one of early Christian type. It is similar to two surviving late fourth- and fifth-century ivory boxes, one now in the City Museum of Brescia in northern Italy (fig. 18), the other originally from the church of St Hermagoras at Pola in Croatia and now in the Archaeological Museum in Venice. These caskets served as reliquaries, but might have begun their lives as containers for the Gospels or other holy books. Not only is the form and construction of the Franks Casket clearly based on such a model; its narrative structure is also similar, with sides and lid carrying a central scene or scenes framed by borders that provide a commentary.

The parallels between the Brescia reliquary and the Franks Casket are particularly striking. Like the Franks Casket, the Brescia casket has panels that slot into corner posts, a central lock and blank areas on the uprights that were originally covered by metal hasps. Its narratives are presented entirely through images, without accompanying text but, as just noted, the scenes in the framing panels form a

visual counterpart to the main scenes. The central panels show scenes that derive from the biblical New Testament while the borders illustrate parallel stories from the Old Testament in an overall scheme centred on icons of salvation. As on the Franks Casket, the Brescia reliquary's panels divide into three thematic groups: the front and back centre on Christ's ministry and disciples; the two ends focus on miracles; and the two lid panels share scenes from the Passion of Christ. A similar interplay of themes unfolds on the Franks Casket, as we shall now see.

There can be little doubt that a fourth- to fifth-century Italian ivory casket of this sort must have been the inspiration for the eighth-century Anglo-Saxon box. This is not as surprising as it may at first seem. In 597 Pope Gregory I (590–604) had sent a Christian mission from Rome (fig. 19), headed by the Benedictine monk Augustine, to convert the English; at much the same time, Celtic missionaries were also active in parts of northern and eastern Britain. By the end of the seventh century most Anglo-Saxons had outwardly adopted the new religion, though lapses into paganism were frequent, and some regions, such as the Isle of Wight, held out to the last; everywhere, memories of the old traditions lingered on. To serve the urgent needs of preaching, baptism, worship and teaching, the new Church imported new kinds of equipment as well as experts from Italy and Frankish Gaul, as the great Northumbrian historian Bede (c.673–735) recorded: bibles, icons and reliquaries, along with masons, glaziers and cantors. A late sixth-century Italian gospel book, which was at St. Augustine's Abbey, Canterbury, from at least the late seventh or eighth century, was traditionally said to have been sent with Augustine's mission. Italian ivory reliquaries and book-boxes, similar to the Brescia casket, could well have arrived by the same route, or have been brought back to Northumbria by Anglo-Saxon monks journeying to Rome; we know that the abbots Benedict Biscop (c.628–690) and Ceolfrith (c.642–716) from Bede's monastery at Wearmouth/Jarrow were active in bringing books and other religious items back to their monastery.

By contrast with the naturalistic depictions on the Italian casket, the crowded scenes and simplified figure style of the

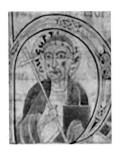

19 Initial with an image of Pope Gregory I, from a copy of Bede's *Ecclesiastical History*, written between AD 731 and 746, about the same time that the Franks Casket was made (detail). St Petersburg, National Library of Russia.

Franks Casket may seem unsophisticated. However, it soon becomes clear that the casket is the work of a skilled and inventive artist, who sought to convey the Christian message by transforming his exotic models into a local Anglo-Saxon idiom, using stories and images familiar to his audience.

A Christian message

In common with its Italian counterparts, the illustration on the Franks Casket requires the meaning to be teased out and digested, rather like a riddle – an entertainment much relished by Anglo-Saxons, but which was also used by the Church as an educational tool, to train agile young minds. At first glance, a link between Weland and the Adoration of the Magi on the front is not immediately apparent, nor is there any obvious connection with the riddling inscription about the beached whale that surrounds both scenes (figs 8, 20). But since the connections between the two scenes on this panel were recognized, scholars have been able to understand how the other scenes might relate to one another, and to tease out the casket's overarching Christian message, which in turn sheds light on its function and origin. It emerges that the scenes on the casket are not a random assemblage of stories, but a carefully constructed series of paired moral tales or parables, in which each pair compares a theme associated with Christian tradition with one drawn from a pagan Germanic one, each illuminating the other.

20 The scenes on the casket's front panel juxtapose two very different images of redemption. *See also* figs 21 and 22.

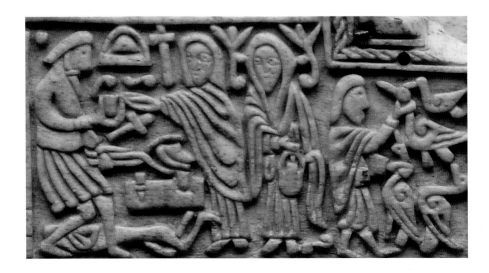

To begin with the front (figs 20–2): it is the principal face of the casket, and its point of entry. Here you unlock it, physically and metaphorically, to reach its contents and its meaning. The riddling inscription about the beached whale suggests that the casket itself is a riddle, to be read at more than its face value; while the similarities and contrasts between the two scenes encourage us to read the casket's other panels in pairs, in which legends from a pagan past and Christian tradition reveal moral lessons that also emphasize the place of Anglo-Saxons in the divine scheme of things.

The two scenes on the front are counterparts, whose main message is one of salvation. In the Christian scene on the right, the homage paid to the newborn Jesus by the three earthly kings acknowledges Christ as king (fig. 22). Their three gifts of gold, frankincense and myrrh refer respectively to his kingship, divinity and mortality, the last foreshadowing his death, through which mankind was saved. Salvation is also implicit in the tale of Weland's grim revenge on a wicked king (fig. 21). Not only is the smith himself an image of deliverance through his magical flight from capture, but through the son he fathered on Beadohild, the future hero Widia, good can be seen to come from suffering. The Anglo-Saxon poem *Deor* also presents the story of Beadohild's fate as a tale of consolation, emphasized through its refrain, 'That passed away; so may this'.

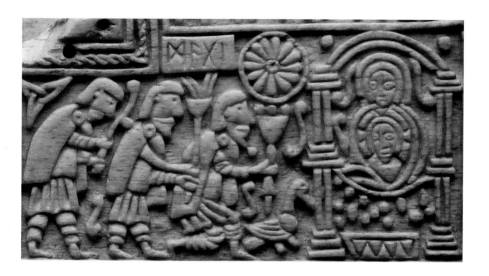

22 Detail from the front panel showing the Adoration of the Infant Jesus by the Magi.

The scenes on the front panel also reflect two underlying themes, exile and kingship, which are echoed elsewhere on the casket. Both Weland and the infant Jesus experience exile (the visit of the Magi prompts the Holy Family's flight into Egypt), and the scenes offer examples of divine and earthly rule, both good and, in the case of wicked King Nithhad, bad. The retribution that awaits a bad king may even be implied in the fate of the stranded whale, described in the accompanying inscription. This riddle is no simple tale of a whale; it too has a subtext. The casket's audience would know the Old Testament story of Jonah's deliverance from the whale, presented in the New Testament as a prefiguration of the death and resurrection of Christ, and so of salvation. Thus the very material from which the casket is made, as well as the riddle about it, echoes the redemptive message of the casket's two front scenes. Moreover, in Anglo-Saxon versions of the popular moralized bestiary known as *Physiologus*, the whale was a terrifying creature, a symbol of the devil who might ensnare you and drag you down to a terrible fate. The word *ga:sric* (king of terror), applied to the dying whale, seems to refer to the fate that awaits wicked kings. Thus it may be no coincidence that the text describing the fate of the whale runs backwards, as if to emphasize the idea of something evil or unnatural. All of this indicates that the casket contains images and texts to be read carefully, and on more than one level.

23 *Right* The casket's lid panel illustrates a Germanic legend, in which a hero defends a fortified place against attack – a theme reflected on the back panel below.

24 *Below* The back panel, depicting the Roman destruction of Jerusalem and its Temple in AD 70, parallells the themes of siege and sanctuary shown on the lid above.

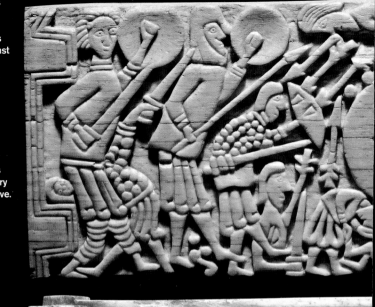

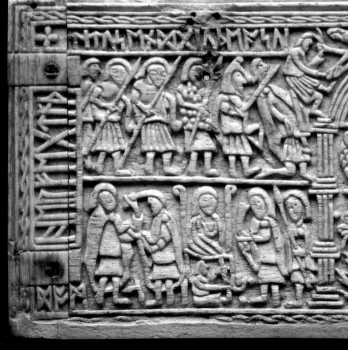

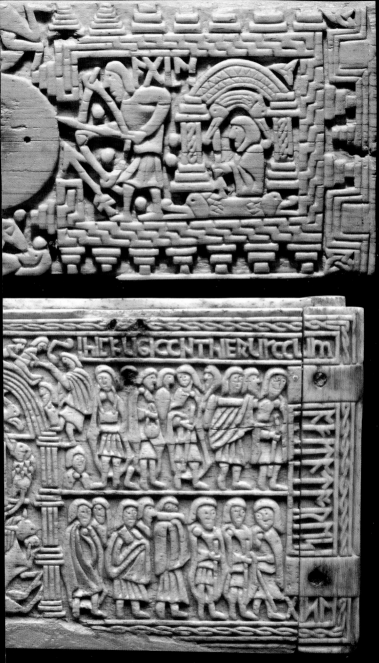

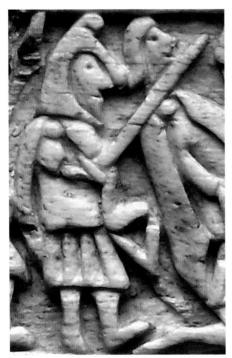 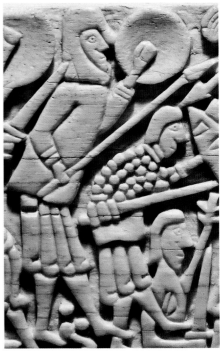

25 *Above* The helmeted general Titus, who leads the assault on Jerusalem, resembles in his bearing and battle-gear the leading warrior on the lid (detail, back panel).

26 *Above right* The leader attacking the fort depicted on the lid wears a helmet, similar to that worn by Titus above, signifying high rank (detail, lid).

The second pair of narratives are on the lid and back panel (figs 23–4). Both depict sieges that take place in the man-made world of towns and fortresses, around buildings in which symbolic creatures inhabit an inner sanctum. Both have prominent helmeted figures: Titus, the Roman general (and later emperor), who attacks the Jewish defenders of Jerusalem on the back panel, and Ægili's unidentified principal assailant on the lid (figs 25–6). We are hampered by our lack of knowledge about the Ægili scene, but it is clear from the similar configuration of the two sieges that they were intended to be read as counterparts. The Roman sack of Jerusalem, centred here on the destruction of Herod's Temple, was seen by some as an emblem of the replacement of the Old Covenant by the New: the replacement of Judaism (represented by Jerusalem) by Christianity (represented by Rome, centre of the Christian Church). This symbol of ascendant Christianity was a message that would have been especially significant for an Anglo-Saxon

27 *Above* An enthroned figure, possibly Titus, dispenses judgement in an image of just rule (detail, back panel).

audience recently converted to Christianity but still very conscious of its pagan past, and its own traditions and stories. The siege of Ægili's sanctuary on the lid presents a Germanic parallel to the fall of Jerusalem on the back, just as the Germanic tale of Weland resonates with the theme of redemption implicit in the Adoration scene.

There are hints, too, of other themes on the back and lid that are also present in the two scenes on the front. The 'judgment' scene on the back, with its enthroned figure – perhaps Titus himself – seems to present an image of just rule (fig. 27). A further reference to the conduct of kings may also be embodied in the prominent assailant on the lid, who, like his counterpart Titus on the back panel, wears a crested Roman-style helmet – a mark of high rank (figs 25–6). The theme of exile that runs through the front panel is picked up in the powerful image on the back panel of the flight of the Jews from Jerusalem, and is also perhaps implied in the 'hostage' scene beneath it (fig. 28).

28 *Right* Scenes depicting the flight of the Jews (above) and the taking of hostages (below) illustrate the recurrent theme of exile on the casket (detail, back panel).

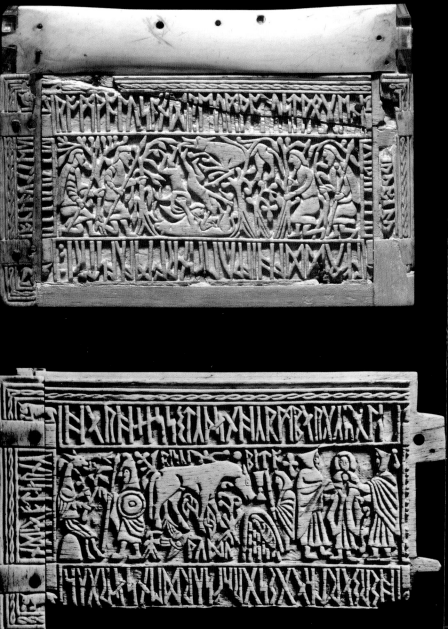

And, as on the other wall panels, the presentation of the main text seems to underline an important part of the message: its abrupt shift into Latin for the words 'here the inhabitants of Jerusalem are fleeing' emphasizes the destruction of Jerusalem by the forces of Rome, symbolizing the end of the old order.

Nowhere are the casket's subtle juxtapositions and artfully constructed texts more apparent than in the final pair of scenes on the two ends (figs 29–30). Although we do not know what Germanic legend lies behind the scene on the right end panel, the two ends still appear to share common elements and to be, in a real sense, counterparts. In contrast to the lid and back panel, the settings on the two ends are not urban, but wild and dangerous natural places in which animals figure prominently. On the right end, the labels explicitly describe the scene as *wudu*, a wood, and *risci*, rushes, suggesting a marshy waterland, while the wolves, and men who hasten to the rescue on the left end, emphasize the intrinsic dangers of the wildwood where the twins Romulus and Remus were abandoned, 'far from their native land'.

The Christian theme of salvation is central to the Romulus and Remus scene. The story of how the twins were rescued by a she-wolf is part of the myth of Rome's foundation by Romulus, its first king. The image of the she-wolf suckling the twins is a long-standing symbol of Rome, but it also came to represent the mother Church of Rome, nourishing the faithful and offering salvation. The (uniquely) upside-down part of the inscription, telling how the she-wolf fed the twins in Rome, underlines the redemptive message: 'A she-wolf nurtured them in Rome city.' The image of the she-wolf and the twins would have been familiar to an Anglo-Saxon audience from Roman coins, which were still available, and from Anglo-Saxon versions of the motif. The wolf and twins appear, for example, on a fifth-century Anglo-Saxon gold amulet pendant from Undley, Suffolk (fig. 31), and on some later silver pennies

41

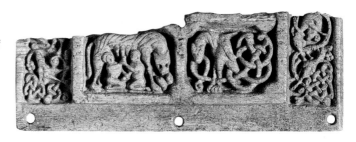

32 An image of the wolf and twins carved on a whale-bone plaque from Larling, Norfolk. Anglo-Saxon, eighth century AD. L. 17.2 cm. Norwich Castle Museum.

of King Æthelbert of East Anglia (d. 794), both of which derive from images on fourth-century Roman coins. A similar scene also appears on an eighth-century bone plate, perhaps from a book cover, from Larling in Norfolk (fig. 32). The secular and religious identity of Rome had particular meaning for newly converted Anglo-Saxons; Bede, for example, speaks about how God ordained the rise of the Roman Empire in order to enable the more rapid spread of his Word. For Anglo-Saxon converts, the story of Romulus who, despite being left to die, founded Rome and became its first king, would have conveyed the Christian message of salvation. At a more general level, the scene also shows how good may come from evil; it alludes to icons of kingship and, once again, to the theme of exile, through the image of the twins rescued 'far from their native land'.

But how might all this relate to the enigmatic scene on the right end of the casket, with its strange array of creatures and humans, both living and dead? What is portrayed there seems a long way from themes of Christian salvation, though we may suspect that kingship and exile have some part to play in its story. The inscription discussed on pp. 28–9, obscure as it is (and made more so by its use of code), can help us a little here. It describes a scene not of salvation, but of explicit oppression, sorrow and torment. Perhaps the use of encrypted runes here also gives a visual clue to a dark and secret theme, just as the retrograde text on the front highlights the sad fate of the whale, or the sudden switch to Latin on the back underlines the flight of the Jews; all flag a key element in the scene that they accompany. We do not know who Hos is, or why she suffers at Ertae's hands, but the three figure groups that compose the scene all, in different ways, suggest oppression or grief. The setting of the story in wildwood and marsh seems to confirm

this as a scene of terrors, for we know from Anglo-Saxon written sources such as the *Life of St Guthlac* that woods and fens were perceived as not just physically dangerous but also spiritually challenging, the haunts of demons and evil creatures. The *Life of St Guthlac* tells of how St Guthlac set out to test his faith by living as a hermit on a tiny island in the fens, significantly next to an ancient burial mound, where he is tormented by evil apparitions, 'unknown monsters . . . and terrors of diverse shapes'.

A deeper comparison with the Romulus scene on the left end panel can now be seen. Though both scenes share a reference to exiled or imprisoned beings at risk from the dangers of the wildwood, it is apparent that, whereas the Christian redemptive interpretation of the wolf and twins signifies life, this panel's theme is death, punishment and imprisonment. Whatever the nature of Ertae's oppression of Hos, the strange hybrid figure clearly suffers an evil constraint. The prominent helmet of the warrior who confronts this creature suggests that he is of high status. Similar warrior figures appear on amulets of the early Viking period in Scandinavia, and are also occasionally found in England; they are thought to represent heroes entering Valhalla, the world of the dead (figs 33–4). The burial mound, with its accompanying figures, takes us into the world of death, while the scene of capture at the right of the panel reinforces the ominous message. This is an image of the harsh and terrible world of the old paganism, in which man is exiled from God's mercy.

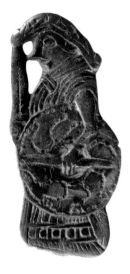

33 *Above* Silver amulet in the form of a warrior with shield and sword, from Wickham Market, Suffolk. Viking period, eighth or ninth century AD. H. 4 cm; W. 2 cm. Ipswich Museum.

34 *Right* The helmeted warrior on the casket's right end panel recalls similar Viking and Anglo-Saxon warrior images, such as fig. 31. Museo del Bargello, Florence.

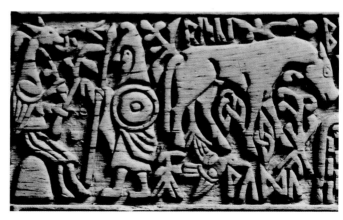

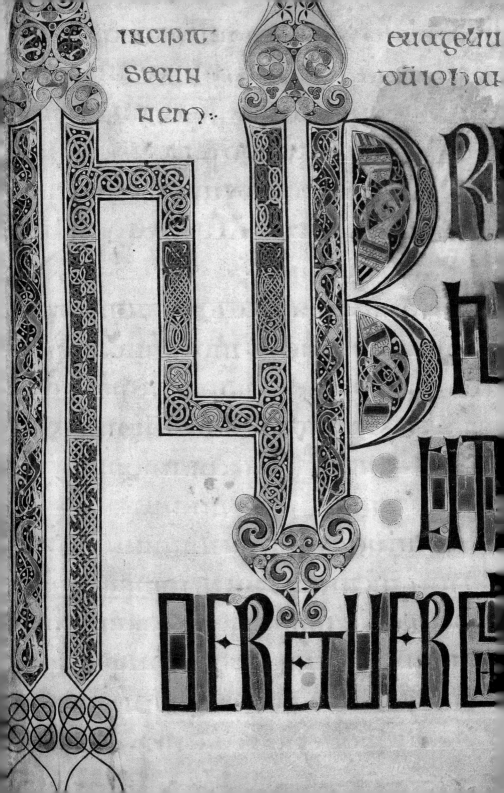

IN
PRI
N
IPI
OERATUERB

Chapter 3
When, where and why?

35 Page (detail) from an Anglo-Saxon gospel, with creatures similar to the crouching animals in the corners of the casket's side and front panels – *see* fig. 36 below. Second quarter of the eighth century AD. Corpus Christi College, Cambridge, ms 197B, f.2.

Made in Northumbria

The distinctive style, language and letter forms of the Franks Casket suggest that it was made in Northumbria, probably shortly after 700. The period was one of intense change and experiment. The Christian missionaries had brought with them not just new kinds of objects that altered the Anglo-Saxon world view, but they also brought literacy, different kinds of learning and new ways of transmitting it. The extraordinarily inventive nature of the Franks Casket and its confident and lively engagement with fresh forms of expression are very much a product of this milieu.

Although the casket's highly stylized and crowded decoration has no close Anglo-Saxon parallel, some of its elements link it stylistically to Northumbrian religious manuscripts and other artefacts of the early eighth century (figs 35–39). The quirky animals crouching in the corners of the front and end panels have parallels in some of these manuscripts, as do the linked beast-heads below the female figure on the lid, and the interlacing birds with curved beaks surrounding the Ark on the back panel (figs 35–7). The casket's figure style is less easy to parallel due to the lack of contemporary illustrated narratives. In contrast to the naturalistic figure style of the great eighth-century Northumbrian stone crosses, its simplified faces and ribbed draperies resemble the much larger figures of Christ, the Virgin and apostles carved on the wooden coffin of St Cuthbert (fig. 38),

36 A creature from one of the four corners of the casket's front panel (detail).

45

37 Decorative elements on the casket are here illustrated (in the left column) alongside similar motifs in seventh- and early eighth-century Anglo-Saxon manuscripts (not to scale). Drawings by M. O. Miller, British Museum.

made around 698 for the saint's enshrinement and reburial on the island of Lindisfarne, off the Northumberland coast. The casket's stylized treatment of the human image also resembles the strongly linear style of figure painting in some early eighth-century Northumbrian manuscripts, such as the Durham *Cassiodorus* (fig. 40). Other stylistic similarities to early eighth-century Northumbrian Gospel books can be seen in the stepped arch bases on the casket's lid and back panels, which resemble those in the arcaded canon tables of these manuscripts.

The casket's inscriptions also share many links with manuscripts. Though expertly – and uniquely for this period – carved in relief, some individual letters are artfully constructed to mimic the sequence of pen-strokes, showing that the carver was fully familiar with writing letters on the

page (figs 41–2). These brilliantly engineered inscriptions also run forwards, backwards, upside down, change alphabet and language or switch into code. They exercise the eye and brain much in the same way as the display scripts of the most elaborate Gospel openings – in which complicated lettering makes an icon of the words – that are seen before they are read (e.g. fig. 35). This visible power of the word underlies the casket's message, and places it firmly in the early eighth-century context of the great Northumbrian Gospel manuscripts.

The art-historical grounds for dating and locating the casket are supported by the language of its inscriptions which also points to an early eighth-century Anglian, probably Northumbrian, origin. Towards the end of the seventh century, the Anglo-Saxon runic alphabet was reformed and standardized, most probably for use by the Church. The maker of the casket used these new rune forms, except on the enigmatic right-hand side where some of the encrypted letters are in the older style. Use of the new rune forms places the casket firmly in the period of transition from the old to the new system, at the start of the eighth century. The presence of the older forms in the encoded

38 *Below right* The casket's distinctive figure style, seen here in the Weland scene, resembles that of the figures carved on St Cuthbert's coffin below (detail, front panel).

39 *Below* Figure of Christ on St Cuthbert's coffin, made c. AD 698 at the Northumbrian monastry of Lindisfarne (after Battiscombe, 1956).

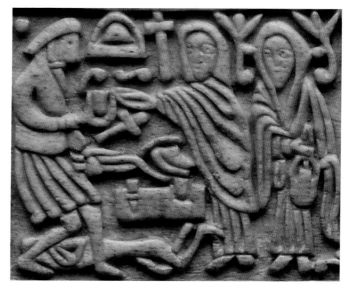

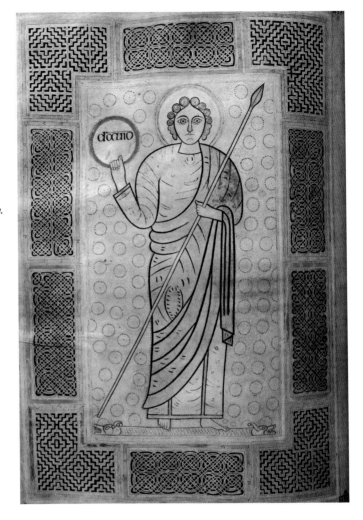

40 Image of Christ as the warrior king David, with a double-headed creature beneath his feet, resembling a similar creature on the casket's lid (fig. 8). Copy of *Cassiodorus*, *Commentary on the Psalms*, early to mid eighth century AD, probably Monkwearmouth/Jarrow, Northumbria. H. 42 cm; W. 29.5 cm. Durham Cathedral Library, ms B.II 30, f.72v.

inscription on the right end suggests that the carver chose them for a particular purpose, perhaps to associate the older, outmoded runic style with a pagan Germanic past.

The northernmost kingdom of Anglo-Saxon England, Northumbria at this time stretched from the Humber into southern Scotland. Although its kings were no longer as powerful as their seventh-century predecessors, some were still forces to be reckoned with. The kingdom was famous for the learning and piety of its great monasteries, such as

Lindisfarne, Whitby, and Monkwearmouth/Jarrow, home to Bede, and for its magnificent illuminated manuscripts and stone sculptures associated with the Church. Everything about the casket – its language, its erudition, its copying of a Roman model, and its juxtaposition of scenes from Germanic, Judaeo-Christian and Roman history – fits such a time and milieu. As we have also seen, the casket can be 'read' on several levels: as a simple collection of stories; as an embodiment of the Christian message of salvation; as a sermon on how good can come from suffering, with a particular emphasis on the theme of exile; and as a moral discourse on the conduct of kings. Together these themes suggest a particular kind of audience: Christian, educated and royal. What this implies for the casket is discussed below.

A learned milieu

The casket's sophisticated use of tales and episodes from very different traditions sits squarely in a learned, probably monastic, context. The use of Anglo-Saxon stories, far from being in conflict with a Christian message, is wholly in step with Gregory the Great's famous instruction to the new Anglo-Saxon Church to adapt pagan Anglo-Saxon temples and festivals to the service of the new religion, using what was familiar in order to make Christianity more attractive and accessible to the population. As we saw in Chapter 2, the paired scenes on the casket present an underlying

41 Part of the Latin inscription on the casket's back panel, imitating the pen-strokes used to form letters in Anglo-Saxon manuscripts, such as fig. 35.

42 Part of the runic inscription on the casket's front panel, showing the careful shaping and overlapping of elements in some of the letters.

message of Christian salvation that draws on both pagan and Christian traditions. This is also in perfect accord with the early medieval Christian concept of universal history, in which events or tales of the past, in all their diversity, are part of the greater history that culminates in the divine message, embodied in Christ. We know that world histories of this type circulated in monastic circles in late seventh- and eighth-century England, because the scholarly Northumbrian king, Aldfrith (685–704), gave land to the monastery at Wearmouth-Jarrow in exchange for just such a manuscript.

Two other Anglo-Saxon traditions have been drawn on in the creation of the casket's narratives: riddles and wisdom texts, such as proverbs and maxims. Both traditions survive in literary compilations from the Anglo-Saxon period and, though they owe something to Latin models as well, there is little doubt that a vigorous oral tradition lay behind them, long preceding the coming of Christianity and literacy – riddles and wise sayings would have been as much a part of Anglo-Saxon everyday life as storytelling and singing. We have seen that the riddle on the casket's front is the starting point for unlocking its meaning, and the riddling theme continues in the interplay of images and texts which has to be puzzled out on the other panels. Typical themes in wisdom literature, such as what conduct befits a king, or the consoling power of the good that can come from evil, are also reflected in the casket.

A royal owner?

Although the casket has a learned and monastic background, two aspects of its overall narrative suggest that it was addressed to a lay, specifically royal, audience. As we saw in the last chapter kings and kingship are prominent on the casket, their stories inviting reflection on good and bad rule. This is most clearly seen in the Adoration scene, where the message of the divine rule to which earthly kings are subject seems very much like a pointed address to a contemporary ruler (fig. 22). Anglo-Saxon kings were essential agents in the spread of Christianity, which they saw as bringing them divine favour and protection, and with it, political advantage. The idea of the

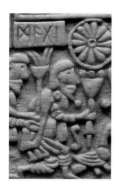

successful Christian ruler, whether victorious warrior or saintly martyr (sometimes both), whose exemplary deeds would bring prosperity and fortune to his people, was especially significant for the competing eighth-century English kingdoms. It is a topic addressed in some of the most influential Anglo-Saxon literary works of the times, which were often either presented to or associated with kings. Bede, for instance, dedicated his *History of the English Church and People* to King Ceolwulf of Northumbria in 731; later, King Offa and Alfred the Great owned copies. Similarly, the Anglo-Saxon monk Felix addressed his Life of the princely warrior, St Guthlac, to King Ælfwald of East Anglia (died *c*.749). Felix's text also emphasizes the pious deeds of another powerful king, Æthelbald of Mercia (d. 757). The casket's running theme of ruler stories, with their moral subtexts, fits such a context very well.

The repeated motif of exile is also significant in this respect: the beached whale, cast up on to an alien shore, the exile of the Holy Family, the imprisoned Weland, the abandoned Roman twins, Romulus and Remus, and the Jews cast out from Jerusalem – all carry reference to exile. This theme is part of the casket's overall message that good can come out of suffering, but it is a message that would also have had a particular resonance for an Anglo-Saxon audience. Exile was a regular experience for seventh- and eighth-century Anglo-Saxon kings and princes, even the most powerful, as Bede's *History* and other sources testify. Northumbrian kings were no exception, and most of its seventh-century rulers spent time in exile; the Aldfrith, for example, passed many long years in Ireland. The casket's stories seem to speak to such experience, using this repeated theme as one of the routes by which its messages could be explored. It is nevertheless reasonable to ask whether such a wide-ranging, complex and many-layered set of stories would have been easily accessible to the average Anglo-Saxon king or prince: certainly few were likely to have been as literate or as clever as Aldfrith. If the casket were made to contain a book, as suggested previously and on page 53, that implies some degree of literacy on the part of its owner. But even if the Anglo-Saxons were not all literate, they were well versed in 'reading' images. Like other societies in which knowledge of writing was confined to only

a few, they had a long tradition, stretching back to the fifth century, of learning through images, rather than written words. For example, the meaning of complicated animal and human motifs on fifth- and sixth-century Anglo-Saxon metalwork, most of it impenetrable to us, would have been understood against a familiar background of communal myths and legends. Just as familiarity with verbal riddles and maxims may have helped an unlearned person to understand the casket, so too the tradition of reading images, associated with familiar tales, would have made the complex matter of the casket more accessible to an illiterate audience than might at first sight be imagined. Weland's exile, for instance, would have been immediately understood as a vital part of his story, as would the exile in to Egypt implied in the Adoration scene. Through this common link, the deeper parallels between the two scenes could be explored.

As all this implies, underneath the intriguing puzzles and engrossing tales, the casket is a deeply didactic object. Its decoration conveyed not only the overarching Christian message of salvation but also, at a more personal level, a set of moral lessons for a Christian ruler of Germanic ancestry, whose own temporal authority, regarded as coming from God, was abused at his peril. If the casket was indeed intended for a royal patron, we can only guess who he might have been. The scholarly Aldfrith (685–704) seems a tempting prospect; not only did he give away land in return for a history of the world, but the great scholar Bishop Aldhelm of Sherborne addressed his collection of *Enigmata* (educational riddles) to him and praised his learning effusively in the Latin dedication. But nothing links Aldfrith, or any other Northumbrian king, directly to the casket. The nearest thing to a clue might unexpectedly lie in the triple knots under the horse's belly and forelegs on the right end panel (fig. 34). The coins of Aldfrith, and of one of his Northumbrian successors, Eadberht (737–58), depict a prancing horse-like creature, which might be some kind of royal emblem. On the coins of Eadberht, this creature also has a triple knot between its legs (fig. 44). Could the resemblance between the horse image on the casket and this

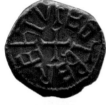

44 Small silver penny of King Eadberht (737–58). The reverse shows a horse-like creature with a triple knot between its legs. British Museum.

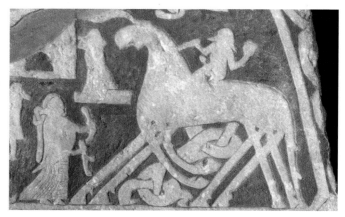

45 Detail of a carved stone monument showing Odin's magical horse, Sleipnir, with triple knots between its legs. Tjängvide, Gotland, Sweden. Early Viking period, eighth century AD. Statens Historiska Museet, Stockholm.

Northumbrian regal symbol link the casket directly to a Northumbrian king? Tempting as this idea might be, an eight-legged horse with triple knots between the legs also appears on some Scandinavian stone monuments, where it is thought to represent the god Odin's eight-legged horse, Sleipnir (fig. 45). It seems more likely that the appearances of this horse with distinctive triple knots reflect a common Germanic tradition, possibly relating to Odin, rather than any direct connection between the casket and the Northumbrian royal dynasty.

What was inside the casket?

The central mystery of what exactly the casket was made for might now be answered if we look again at its underlying themes. The Christian message implies that the casket and its contents were intended to guide its owner in the exercise of the Christian life and, more specifically, in Christian kingship. The casket's size and portability suggest that it was designed to hold a book, perhaps the Gospels or, as has recently been proposed, a copy of the Psalms, said to have been composed by King David. The Psalms are rich in instruction and meditation on the godly life, including the conduct of kings, and David was regularly presented by early medieval Christian writers as a role model for contemporary rulers. There could hardly be a more fitting possession for an early eighth-century Anglo-Saxon king than David's own exemplary text, housed in a precious container that linked a Germanic past with the new Christian message.

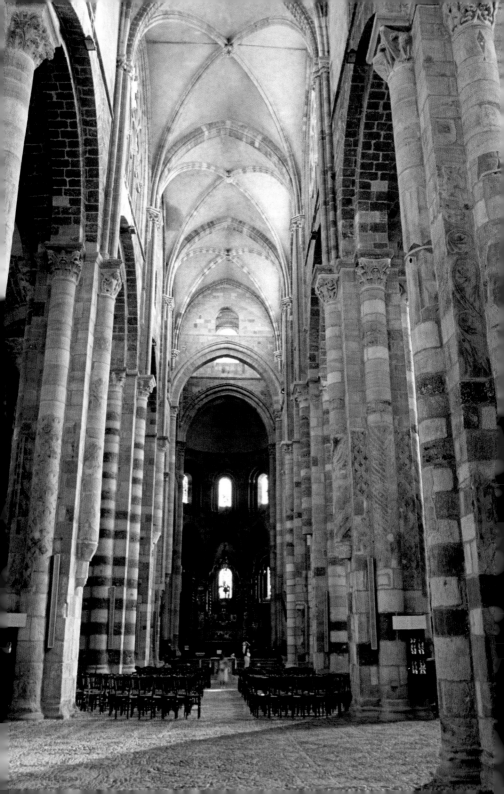

Puzzling out the past

46 Interior of the
Romanesque church
of St Julian at Brioude,
France, looking
towards the high altar
on which the Franks
Casket was probably
once displayed.

A French discovery

The final riddle of the casket is that of its mysterious past.
The history of the Franks Casket is full of puzzles, but recent
studies have begun to fill in some major gaps. It first came to
light towards the middle of the nineteenth century, when a
local historian, Professor P.-P. Mathieu obtained it from a
middle-class family living in Auzon, in the Département of
Haute-Loire, France. The casket by then had fallen into
pieces, and one of its panels was missing. According to
Mathieu, it had been used by the ladies of the house as a
workbox to keep their sewing materials in, but had collapsed
when a son had sold off its silver fittings to buy a signet ring.

The casket, or most of it, had clearly been rescued from a
dismal fate, but what happened next is unclear. By the late
1850s, the panels acquired by Mathieu had entered the
possession of Jean-Baptiste Joseph Barrois, a well-known
Parisian collector with an interest in both the medieval period
and ancient scripts. The casket, with its Anglo-Saxon runes
and curious scenes, must have appealed to him on both
counts. After Barrois's death in 1855, the panels passed into
the possession of a dealer in Paris. News of this intriguing
object had reached the British Museum by the summer of
1858, when on 6 July the formidable Keeper of Manuscripts,
Sir Frederic Madden, wrote in his journal:

> Mr. Franks came to my room and shewed me the remains of
> a box carved out of whale bone, with inscriptions on it in
> Anglo-Saxon Runes. It formerly belonged to M. Barrois, and
> I thought its authenticity doubtful, but on inspecting it very
> narrowly, I am bound to say I believe it to be genuine ... It is
> certainly the most singular relic of Anglo-Saxon art that exists.

At that time a junior curator in the Museum's Department of
Antiquities, Franks (fig. 47) had heard about the casket panels
from J. C. Robinson, a curator at the South Kensington Museum

47 Augustus Wollaston Franks, who presented the casket to the Museum in 1867. Bronze portrait medal by Charles J. Praetorius. Diam. 55.5 cm. British Museum.

(now the Victoria and Albert Museum), and arranged for them to be offered to the British Museum through a London dealer, for the sum of 100 guineas (£105 sterling, nowadays worth around £63,000). Even by contemporary standards, this was an extremely reasonable price for such an exceptional object. However, on 10 July 1858, the Trustees of the British Museum declined the purchase ('they had never committed a greater act of folly', wrote Madden in disgust) and Franks bought the panels himself, presenting them to the Museum nine years later. But where was the missing right end panel (fig. 30), which, along with the corner piece it fitted into, had become separated from the other components before Mathieu first saw them? In March 1867 Franks wrote to the runic scholar George Stephens that Mathieu had offered a reward for it, but had been told that the missing panel was 'supposed to have been thrown away on a heap and carried out to manure the vines'. The rumour was as inaccurate as it was lurid. In fact, it had apparently turned up later in a drawer in the house at Auzon, and was subsequently acquired by the avid collector Jean-Baptiste Carrand, who had moved to Paris from Lyons in 1835 to be close to the salerooms. Carrand's extensive collection was particularly rich in objects from the later medieval and Renaissance periods, though he may also have had an interest in runes, as he owned a medieval Scandinavian horn with a runic inscription. Carrand died in 1871, and in 1888 his entire collection, including the missing panel from the casket, was bequeathed by his son Louis to the Bargello Museum in Florence, where the panel remains on display to this day. On the casket in the British Museum, the right end panel is represented by a replica.

The first descriptions of the casket were published independently in 1866–7 by George Stephens and the scholar D. H. Haigh. The whereabouts of the missing end had been known to the British Museum for some time before it went on display in the Bargello, but it was not until 1890 that it came to public knowledge, generating a discreetly acrimonious tussle among scholars to be the first to pronounce on this discovery. Since then, the casket's intriguing scenes and their accompanying runic texts have continued to generate an enormous literature and considerable debate.

Where was it in the Middle Ages?

It is not known why, when or how the Franks Casket first arrived in France, let alone the remote area of the Auvergne, though there are some persuasive clues. Its history before it was discovered in Auzon is mostly obscure, but judging from its condition, it is evident that for most of its life the casket had been well cared for, and carefully repaired. This fact, together with the Christian elements in its decoration, suggest that it was probably preserved in a church. A local tradition, noted in the late nineteenth century by a visiting curator from the Victoria and Albert Museum, recounts that the casket did indeed survive in a church; not that of St Laurent at Auzon, even though this is an early foundation, and possesses an early medieval reliquary of apparently Insular origin, but the much larger and grander church of St Julian in the nearby town of Brioude (figs 46 and 48). A place of pilgrimage since the fifth century, it was famous throughout France for the shrine of its local martyr and patron saint. Recently, documentary references supporting this tradition have been recognized in the archives at Brioude, suggesting that the casket might be identified with an important reliquary kept on the high altar of the church. The earliest of these refers to an accord reached in 1291 between the dean and chapter of the church of St Julian, and Béraud, lord of Mercoeur, in which :

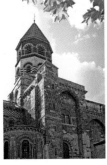

48 Exterior view of the church of St Julian at Brioude, which attracted many pilgrims to the saint's shrine during the medieval period.

the aforesaid noble lord of Mercoeur made homage and swore loyalty to St Julian, to the chapter and church of Brioude, and to the aforesaid dean, hand on the holy gospels, and devoutedly kissing a box of ivory filled with relics, as is the barons' custom.

The ivory box described almost certainly contained relics of the saint himself, and was evidently seen as a potent symbolic possession of the church, and of the cult of St Julian. Some 300 years later, a casket is again mentioned in connection with St Julian at Brioude: a plaque from the saint's tomb, which records the transfer of his relics in 1606, also describes a casket (*arcula*) on the high altar, containing relics of the saint. This record is supported by a later account of 1660, which refers to an ivory coffer on the

high altar housing a tooth of St Julian and several other relics, also listed in an inventory of 1634. This ivory coffer is in all probability the casket described in the 1606 record, as the only other reliquaries listed in these accounts are specifically described as reliquaries of silver or gilded metal. These brief mentions are not precise enough to be conclusive, but given the considerable rarity of bone or ivory reliquaries, the existence of an important one at Brioude as early as the thirteenth century suggests a very plausible context for the casket in the Middle Ages.

Like a number of other Anglo-Saxon religious objects that survived in continental churches, the casket was probably brought to France during the Anglo-Saxon period, when there was regular traffic of royalty and high-status ecclesiastics between France and England. Any one of these might have presented this prestigious object as a gift to a favoured shrine or religious community. Of course, the gift need not initially have been to the shrine of St Julian; it could have been brought there from somewhere else. And if the casket was made to contain a holy book, as suggested earlier, it may have been on account of its precious content that such a gift was made. But once book and box had become separated, the possible reasons for the casket's survival, even veneration, become more intriguing.

What could such an exotic object as the casket have meant at the shrine of St Julian, to the extent that it came to hold relics of the saint himself, and that the local barons swore sacred oaths upon it? As neither the casket's language nor its runic lettering, let alone the scenes from Germanic legend, would have been intelligible to a Frankish audience, a correct reading of the casket's iconography would have been virtually impossible. Nevertheless, the Adoration of the Magi and the Romulus and Remus scenes probably would have been recognizable, and sufficient together to indicate the Christian nature of the box (figs 8 and 13).

It is also possible that some of the Germanic scenes could have acquired a local significance, once their original meanings were lost; there are plenty of other examples of this kind of appropriation from the early medieval period.

In his *Passio of St Julian the Martyr*, the sixth-century Frankish historian, Gregory of Tours, gives a clue to the casket's possible meaning for the faithful at Brioude. He describes how, during Burgundian raids in the Auvergne, the hero Hillidius successfully defended Julian's shrine against armed marauders. Later, Gregory recounts another raid on the church, this time by the soldiers of the Frankish king Theuderic, in which the church was looted. The looters were struck down by divine retribution, prompting Theuderic to return the treasures. Even though the casket must have come to the shrine at Brioude long after Gregory wrote his account, it is possible that its two scenes of siege, on the lid and the back, were interpreted locally as versions of these celebrated events, directly relating the casket to the saint's cult. The defender of a sanctuary on the lid could have been interpreted as Hillidius, and the scenes on the back, showing the sacked and emptied Temple and the dispensing of justice, might equally have been understood as the events surrounding the raid in Theuderic's time.

One last question remains. How did the casket come to leave its safe ecclesiastical haven at Brioude, to end up in private hands at Auzon? The context for this almost certainly lies in the dispersal and destruction of many church treasures during the period of the French Revolution

49 The defence of a sanctuary, like that depicted on the lid and shown here, had special meaning for the medieval French guardians of the relics of St Julian at Brioude.

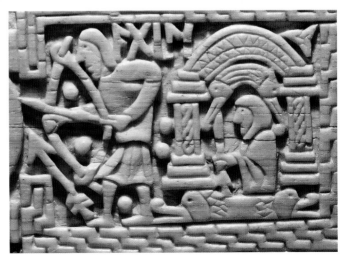

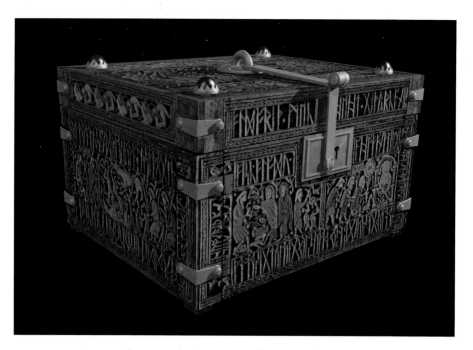

50 A reconstruction of the casket as it might once have appeared, with metal fittings, jewelled insets and brightly coloured panels. Computer generated image by Stephen Crummy, British Museum.

(1789–99). On 4 November 1793 the Conseil Général at Brioude decreed that :

> All the gold and silver objects in the parish church, which have no use in worship and only owe their existence to pride and ostentation ... will be transferred to the municipality, to be subsequently sent to the Convention, and converted into coin.

Fortunately, it seems that Brioude's treasures never reached Paris, as no record of any items of precious metal from the church survives in the registers of the national mint. Other accounts of the dispersal of church valuables during the revolutionary period suggest that some treasures sent to the mint were similary 'lost' en route, whether hidden away by pious people or simply stolen. After Napoleon (1769–1821) came to power in 1799, traditional religious practice was once again permitted in France, and little by little some pieces emerged from hiding. Could this have been the story of the Franks Casket?

Postscript

One of the more astonishing things about the casket is its journey down to the present day, passing from one owner to another during the thirteen centuries of its existence, after an evidently eventful history in which it has narrowly escaped destruction on more than one occasion. Along with its air of mystery, its elliptical portrayal of Germanic legend and its runic puzzles, its survival is part of the casket's appeal today. It speaks of a heroic past in more than one sense, just as it did for the barons during its many centuries in Brioude, and for the Victorians who saw in it some of the earliest roots of Englishness.

What is perhaps most remarkable is the simple fact that it has, for over 1,300 years, continued to exert not just a fascination for the curious, but to have convinced successive audiences that it was an object that could still have meaning in a Christian context, no matter how unintelligible the language, or how puzzling its busy figures, its runes and its riddles. The boldness and directness of its conception, and especially its visual language, express a supreme confidence in its message, which has inspired generation after generation to find their own interpretations of it. For the recently converted Anglo-Saxon folk for whom it was made, the casket told how the heroic stories of a pagan past could be relevant to the Christian message; and over a thousand years later, the spirit of Pope Gregory I's mission to the English is still visible in it.

One of the most arresting and intellectually complex icons of Anglo-Saxon culture, the Franks Casket is a virtuoso demonstration of how the past can illuminate the present, through ancient narratives that speak to us today as directly as they must have spoken to its first audience so long ago.

Further reading

R. Abels, 'What has Weland to do with Christ?: the Franks Casket and the Acculturation of Christianity in Early Anglo-Saxon England', *Speculum* 84, no. 3 (July 2009).

C. J. E. Ball, 'The Franks Casket: right side', *English Studies* 47 (1966), pp. 1–8.

C. J. E. Ball 'The Franks Casket: right side – again' *English Studies* 55 (1974), p. 512. This and the previous article are groundbreaking discussions of the encrypted text.

A. Becker, *Zum Runenkästchen von Auzon (Regensburger Arbeiten zur Anglistik und Amerikanistik, Bd. 5)*, Regensburg 1973. A different approach to the casket; *see also* his Franks Casket website.

J. Berger '"Redécouverte" des reliquaires de la collégiale Saint-Laurent d'Auzon', in D. Quast, *Das merowingerzeitliche Reliquienkästchen aus Ennabeuren – eine Studie zu den frühmittelalterlichen Reisereliquiaren und Chrismalia (mit Beiträgen von Jean Berger und Roland Deigendesch). Kataloge vor-und frühgeschichtlicher Altertümer*, Mainz, 2011. New light on Auzon in the early medieval period.

M. Caygill, '"Some recollection of me when I am gone": Franks and the early medieval archaeology of Britain and Ireland', in M. Caygill and J. Cherry (eds), *Augustus Wollaston Franks: Nineteenth-Century Collecting and the British Museum*, London 1997, pp. 160–83. This gives documentary sources for the acquisition of the casket by the British Museum.

R. Cramp, *Bede and Judgement: The Wearmouth Lecture 2009* (privately printed).

R. W. V. Elliott, *Runes* (2nd edn), Manchester 1989, pp. 123–39. This book has a useful bibliography.

N. Francovich Onesti, 'Roman themes in the Franks Casket', in *L'Antichità n ella cultura europea del Medioevo/ L'Antiquité dans la culture européenne du Moyen Age. Ergebnisse der internationalen Tagung in Padua 27.09.-01.10.1997*. Greifswald 1998, pp. 295–313. A valuable study.

J. Lang, 'The imagery of the Franks Casket: another approach', in J. Hawkes and S. Mills (eds), *Northumbria's Golden Age*, Stroud 1999, pp. 247–55.

H. Marquardt, *Bibliographie der Runeninschriften nach Fundorten, 1. Die*

Runeninschriften der Britischen Inseln, Göttingen 1961. A comprehensive bibliography for the casket up to 1961.

A. S. Napier, 'The Franks Casket', in *An English Miscellany presented to Dr. Furnivall*, Oxford 1901, pp. 362–81. A detailed and balanced interpretation of the inscriptions, still relevant today.

C. Neumann de Vegvar, 'Reading the Franks Casket: context and audiences', in V. Blanton and H. Scheck (eds), *Intertexts: Studies in Anglo-Saxon Culture Presented to Paul E. Szarmach*, Tempe 2008, pp. 141–59. A valuable discussion of wisdom literature in relation to the casket, and a useful updating of the bibliography.

R. I. Page, *An Introduction to English Runes* (2nd edn), Woodbridge 1999, pp. 172–9. Essential reading for the runic background.

D. N. Parsons, *Recasting the Runes: the Reform of the Anglo-Saxon Futhorc* (*Runrön* 14), Institutionen för nordiska språk, Uppsala Universitet, Uppsala 1999, pp. 98–100. Important for, among other things, placing the casket in the context of a critical shift in runic usage.

L. E. Webster, *Anglo-Saxon Art*, London 2012. A useful background to the subject.

L. E. Webster, 'Stylistic aspects of the Franks Casket', in R. T. Farrell (ed.), *The Vikings*, Chichester 1982, pp. 20–31.

L. E. Webster, 'The iconographic programme of the Franks Casket', in J. Hawkes and S. Mills (eds), *Northumbria's Golden Age*, Stroud 1999, pp. 227–46.

L. E. Webster, 'Le coffret d'Auzon: son histoire et sa signification', in A. Dubreucq, C. Lauranson-Rosaz, B. Sanial (eds), *St Julien et les origines de Brioude* (*Actes du Colloque International de Brioude, 22–25 septembre 2004*) (Almanach de Brioude, CERCOR, 2007), pp. 314–30. Includes an account of the evidence for the casket's association with Brioude.

L. E. Webster and J. Backhouse (eds), *The Making of England. Anglo-Saxon Art and Culture, AD 600–900*, London 1991, pp. 101–3.

I. Wood, 'Ripon, Francia and the Franks Casket in the early Middle Ages', *Northern History* 26 (1990), pp. 1–19.

Picture credits

Every effort has been made to trace the copyright holders of the images reproduced in this book. All British Museum photographs are © The Trustees of the British Museum.

1 Photo: British Museum; 1867,0120.1. Given by Sir Augustus Wollaston Franks
2 Photo: British Museum
3 Photo: British Museum
4 Photo: British Museum
5 Photo: British Museum
6 Photo: British Museum
7 Photo: British Museum
8 Photo: British Museum
9 Photo: British Museum
10 Photo: British Museum
11 Photo: British Museum
12 Photo: British Museum
13 Photo: British Museum
14 Museo del Bargello, Florence
15 Museo del Bargello, Florence
16 Museo del Bargello, Florence
17 Museo del Bargello, Florence
18 Per concessione dei Civici Musei d'arte e storia di Brescia
20 Photo: British Museum
21 Photo: British Museum
22 Photo: British Museum
23 Photo: British Museum
24 Photo: British Museum
25 Photo: British Museum
26 Photo: British Museum
27 Photo: British Museum
28 Photo: British Museum
29 Photo: British Museum
30 Photo: British Museum
31 Photo: British Museum; 1984,1101.1
32 Norwich Castle Museum, inv. no. 184.970
33 Colchester and Ipswich Museum Service
34 Museo del Bargello, Florence
35 MS 197B, fol. 2r; The Master and Fellows of Corpus Christi College, Cambridge
36 Photo: British Museum
37 Drawings: M.O. Miller
38 Photo: British Museum
39 Drawing: author
40 MS B.II 30, fol. 72v; by permission of Durham Cathedral
41 Photo: British Museum
42 Photo: British Museum
43 Photo: British Museum
44 Photo: British Museum; 1935,1117.513
45 Statens Historiska Museet, Stockholm
46 © age fotostock / Superstock
47 Photo: British Museum; 1898,0302.1
49 Photo: British Museum
50 Photo: British Museum